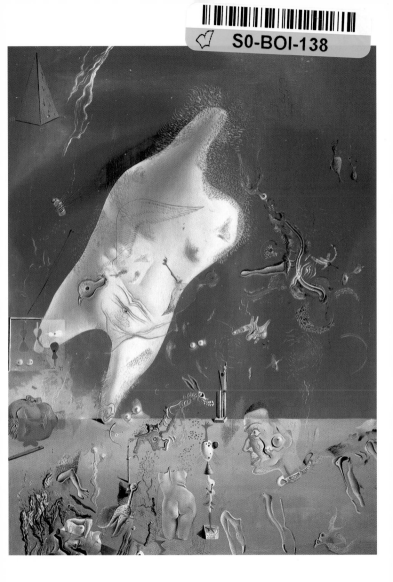

Salvador Dalí
Senicitas (also: Summer Forces and: Birth of Venus), 1927–1928
Senicitas (auch: Sommerliche Kräfte und: Geburt der Venus)
Senicitas (ou: Forces Estivales et Naissance de Vénus)
Madrid, Museo Español de Arte Contemporáneo

TASCHEN

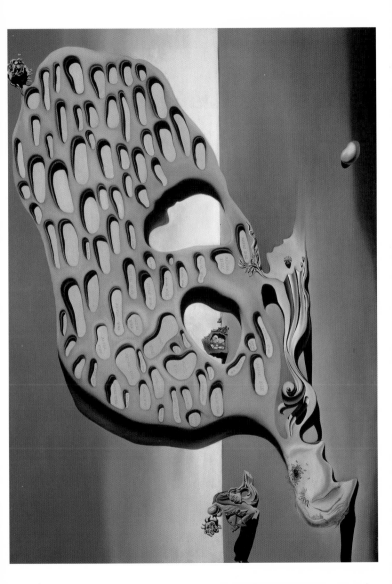

Salvador Dalí
The Enigma of Desire – My Mother, My Mother, My Mother, 1929
Das Rätsel der Begierde – Meine Mutter, meine Mutter, meine Mutter
L'Énigme du désir – Ma mère, ma mère, ma mère
Munich, Staatsgalerie moderner Kunst

TASCHEN

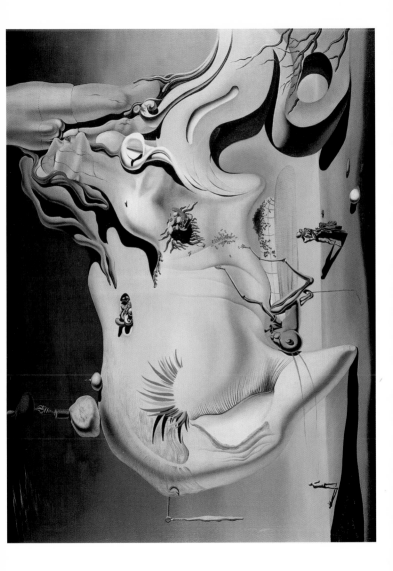

Salvador Dalí
The Great Masturbator, 1929
Der große Masturbator
Le grand Masturbateur
Gift from Dalí to the Spanish state

TASCHEN

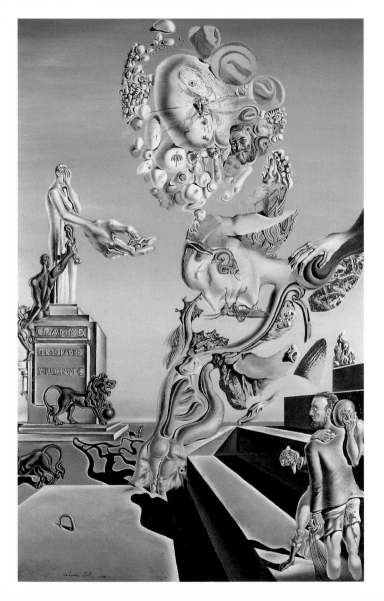

Salvador Dalí
The Lugubrious Game, 1929
Das finstere Spiel
Le Jeu lugubre
Private collection

TASCHEN

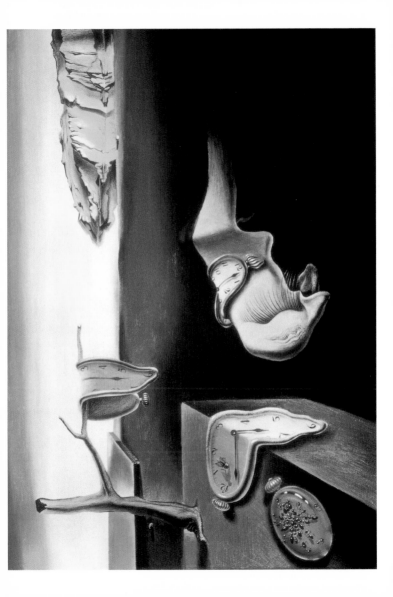

Salvador Dalí
The Persistence of Memory, 1931
Die Beständigkeit der Erinnerung
La Persistance de la mémoire
New York, The Museum of Modern Art

TASCHEN

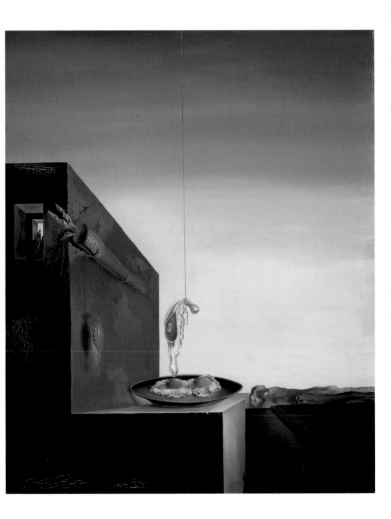

Salvador Dalí
Fried Eggs on a Plate without the Plate, 1932
Spiegeleier auf dem Teller ohne Teller
Œufs sur le plat sans le plat
St. Petersburg (FL), Collection of Mr. and Mrs. A. Reynolds Morse,
on loan to the Salvador Dalí Museum

TASCHEN

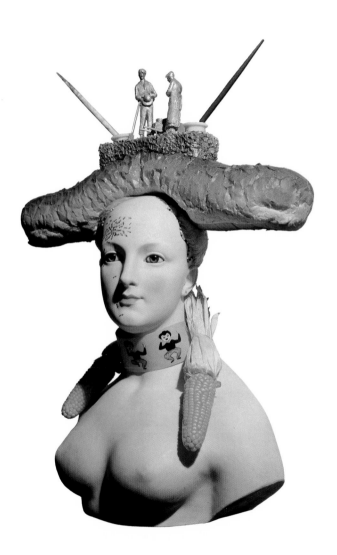

Salvador Dalí
Retrospective Bust of a Woman (present state), 1933 (1970)
Retrospektive Frauenbüste (jetziger Zustand)
Buste de femme rétrospectif (état actuel)
Belgium, Private collection

© 2003 TASCHEN GMBH, KÖLN

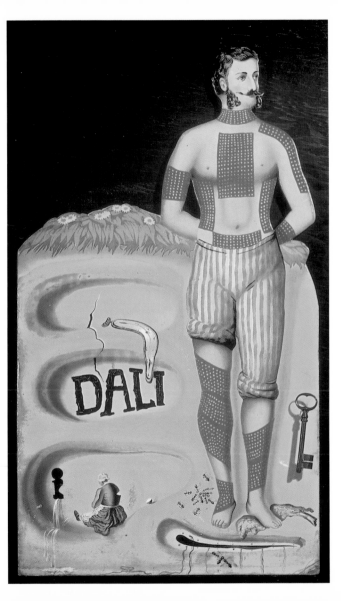

Salvador Dalí
Surrealist Poster, 1934
Surrealistisches Plakat
Affiche surréaliste
St. Petersburg (FL), Collection of Mr. and Mrs. A. Reynolds Morse,
on loan to the Salvador Dalí Museum

TASCHEN

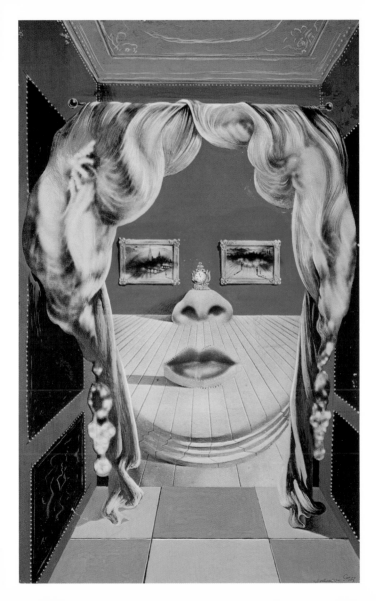

Salvador Dalí
Mae West's Face Which Can Be Used as a Surrealist Apartment,
1934–1935
Gesicht der Mae West (kann als surrealistisches Appartement
benutzt werden)
Visage de Mae West (pouvant être utilisé comme appartement
surréaliste)
Chicago (Ill.), The Art Institute of Chicago

TASCHEN

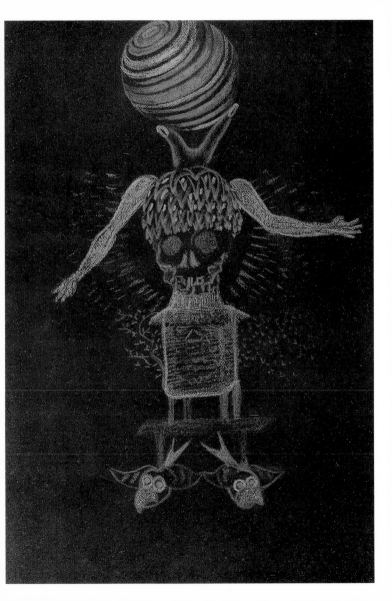

© 2003 TASCHEN GMBH, KÖLN

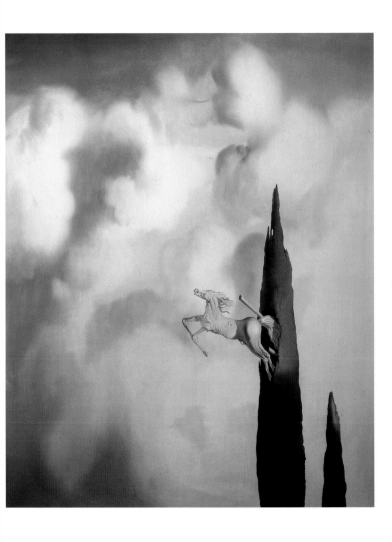

Salvador Dalí
Morning Ossification of the Cypress, 1935
Morgendliche Verknöcherung der Zypresse
Ossification matinale du cyprès
Private collection, formerly collection of Anne Green

TASCHEN

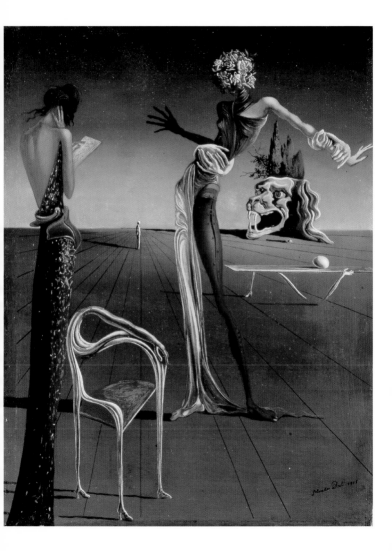

Salvador Dalí
Woman with Head of Roses, 1935
Frau mit Rosenhaupt
Femme à la tête de roses
Zurich, Kunsthaus Zürich

TASCHEN

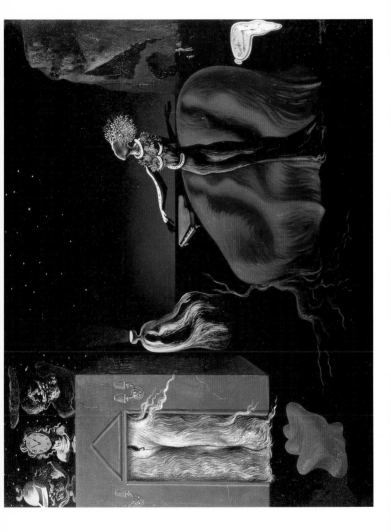

Salvador Dalí
Singularities, 1935–1936
Eigenarten
Singularités
Figueras, Teatro-Museo Dalí, on loan to the Fundación Gala-
Salvador-Dalí, Figueras

TASCHEN

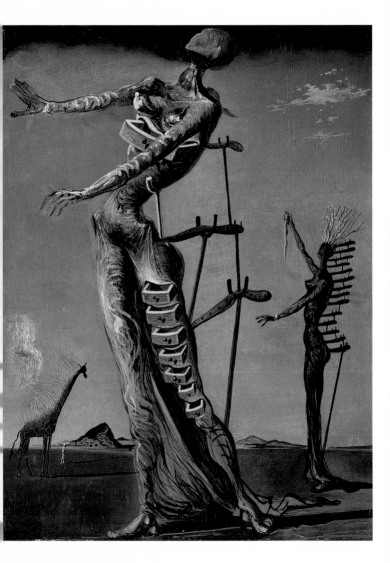

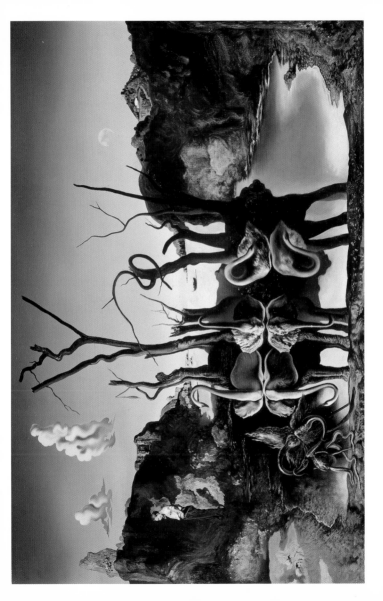

Salvador Dalí
Swans Reflecting Elephants, 1937
Schwäne spiegeln Elefanten wider
Cygnes réfléchis en éléphants
Private collection

TASCHEN

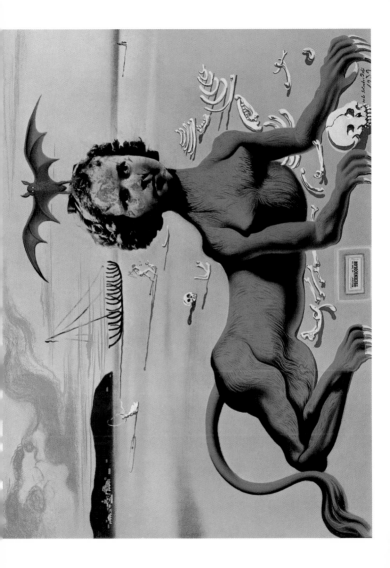

Salvador Dalí
Shirley Temple, the Youngest Scared Monster of Contemporary
Cinema, 1939
Shirley Temple, das jüngste geheiligte Ungeheuer des
zeitgenössischen Kinos
Shirley Temple, le plus jeune monster sacré du cinéma de son
temps
Rotterdam, Boymans-van-Beuningen Museum

TASCHEN

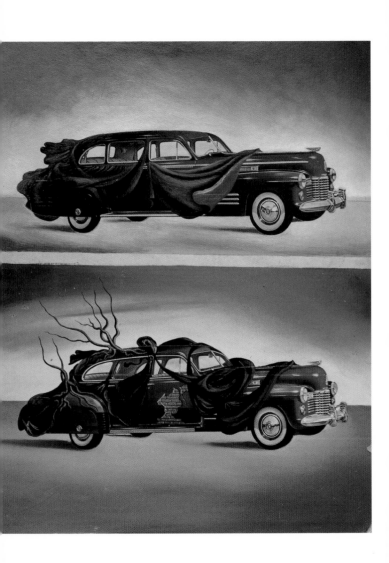

Salvador Dalí
Clothed Automobile, 1941
Bekleidetes Automobil
Automobile habilée
Figueras, Fundación Gala-Salvador-Dalí

TASCHEN

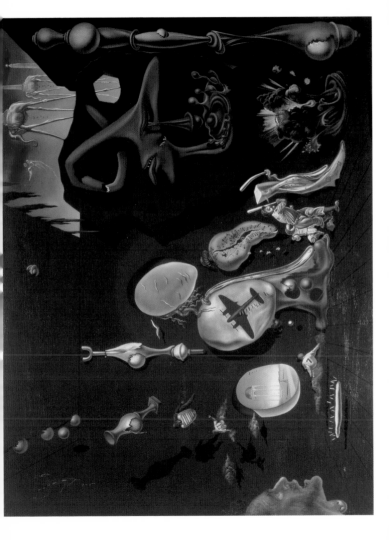

Salvador Dalí
Atomica Melancholica, 1945
Melancholische Atom- und Uranidylle
Idylle atomique et uranique mélancolique
Gift from Dalí to the Spanish state

TASCHEN

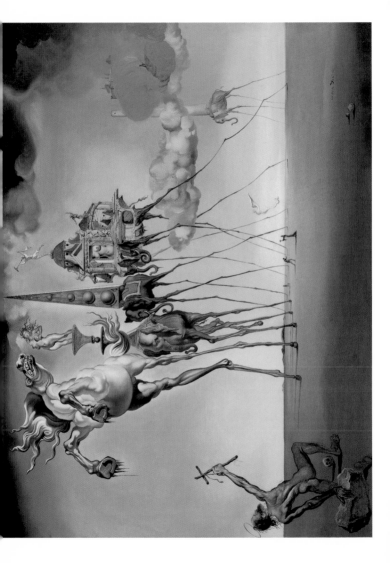

Salvador Dalí
The Temptation of Saint Anthony, 1946
Die Versuchung des heiligen Antonius
La Tentation de saint Antoine
Brussels, Musées Royaux des Beaux-Arts de Belgique

TASCHEN

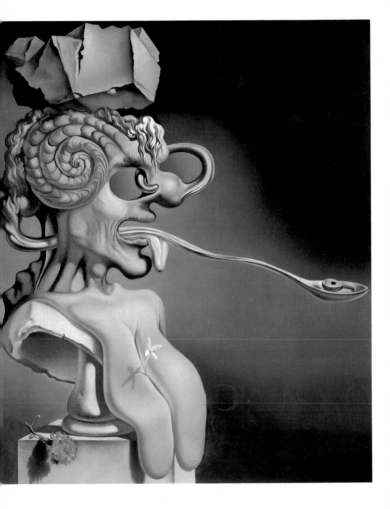

Salvador Dalí
Portrait of Picasso, 1947
Bildnis Picasso
Portrait de Picasso
Figueras, Fundación Gala-Salvador-Dalí

TASCHEN

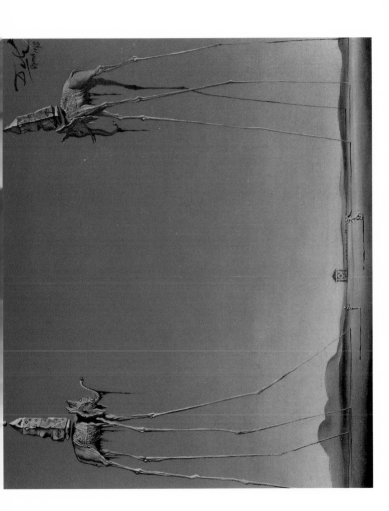

Salvador Dalí
The Elephants, 1948
Die Elefanten
Les Éléphants
Private collection

TASCHEN

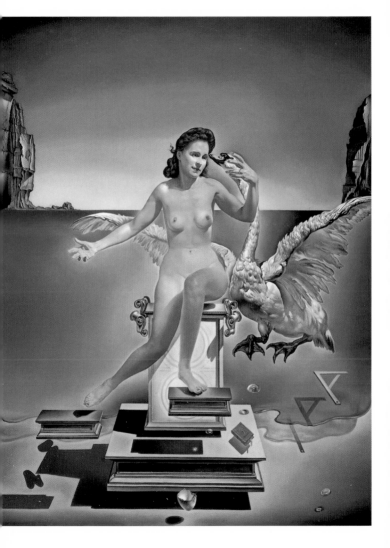

Salvador Dalí
Leda Atomica 1949
Figueras, Teatro-Museo Dalí

TASCHEN

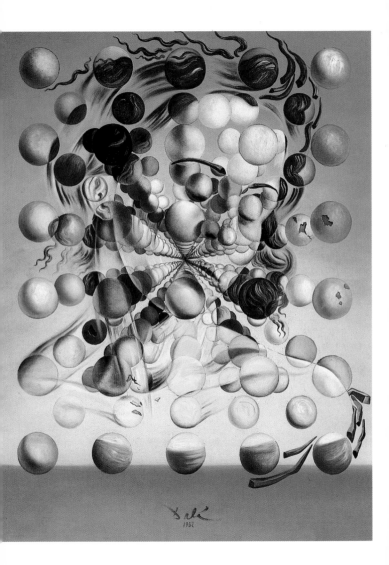

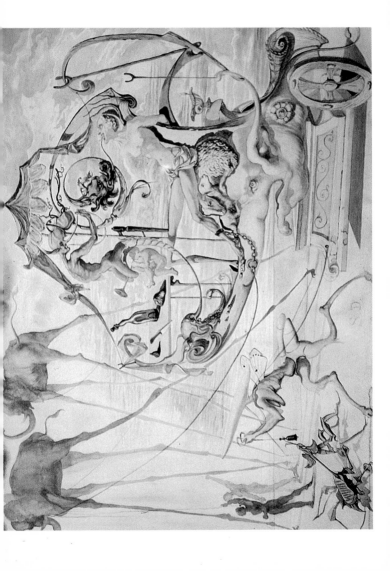

Salvador Dalí
The Vintagers: the Bacchus Wagon, 1953
Die Weinleser: der Bacchus-Wagen
Les Vendangeurs: le char de Bacchus
Private collection

TASCHEN

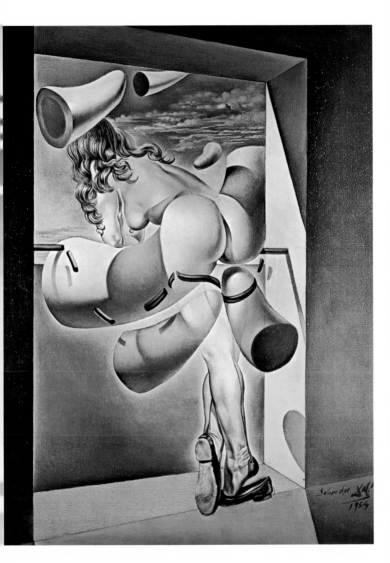

Salvador Dalí
Young virgin Autosodomized by her Own Chastity, 1954
Autosodomisierte jugendliche Jungfrau
Jeune vierge autosodomisée
Los Angeles, Playboy Collection

TASCHEN

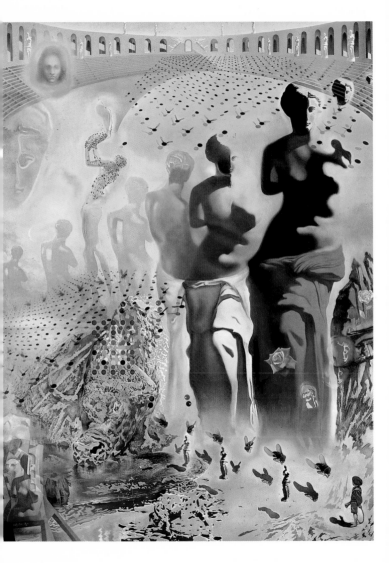

Salvador Dalí
Hallucigenic Bullfighter, 1968–1970
Halluzinogener Torero
Le Toréro hallucinogène
St. Petersburg (FL), Collection of Mr. and Mrs. A. Reynolds Morse,
on loan to the Salvador Dalí Museum

TASCHEN

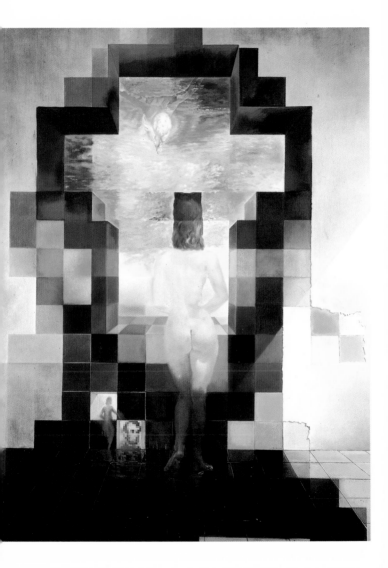

Salvador Dalí
Gala Looking at the Mediterranean Sea which from a Distance of 20
Meters is Transformed into a Portrait of Abraham Lincoln, 1976
Gala betrachtet das Mittelmeer, das sich in einer Entfernung von
zwanzig Metern in das Bildnis Abraham Lincolns verwandelt
Gala regardant la mer Méditerranée qui à vingt mètres se
transforme en portrait d'Abraham Lincoln
Tokyo, Minami Museum

TASCHEN